T0150626

THE WATSON GORDON
LECTURE 2014

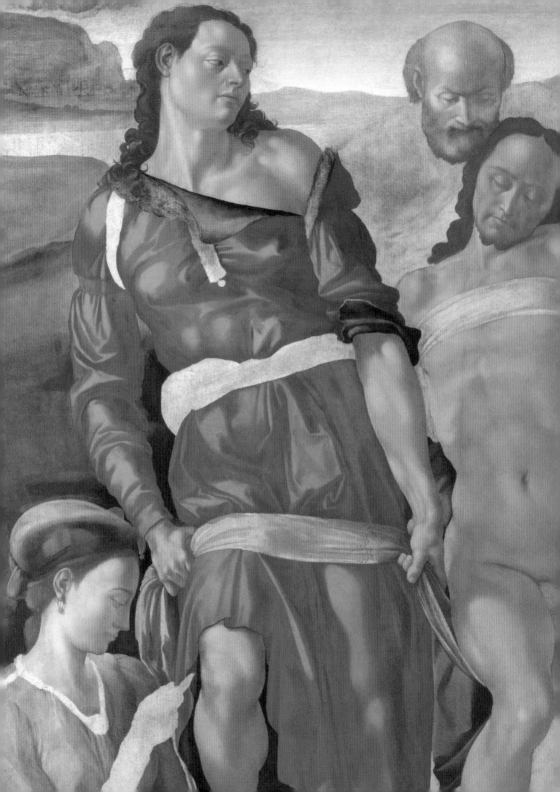

THE WATSON GORDON
LECTURE 2014

Unfinished Paintings:
Narratives of the Non Finito

DAVID BOMFORD

NATIONAL GALLERIES OF SCOTLAND
in association with
THE UNIVERSITY OF EDINBURGH

Published by the Trustees
of the National Galleries of Scotland, Edinburgh
in association with The University of Edinburgh
© The author and the Trustees of the National Galleries of Scotland 2015

ISBN 978 1 906270 91 9

Frontispiece: detail from Michelangelo Buonarroti (1475–1564)
*Entombment, c.*1500 (fig.4)
Designed and typeset in Adobe Arno by Dalrymple
Printed and bound on Arctic Matt 150gsm
by OZGraf SA, Poland

FOREWORD

The publication of this series of lectures has roots deep in the cultural history of Scotland's capital. The Watson Gordon Chair of Fine Art at the University of Edinburgh was approved in October 1872, when the University Court accepted the offer of Henry Watson and his sister Frances to endow a chair in memory of their brother Sir John Watson Gordon (1788–1864). Sir John, Edinburgh's most successful portrait painter in the decades following Sir Henry Raeburn's death, had a European reputation, and had also been President of the Royal Scottish Academy. Funds became available on Henry Watson's death in 1879, and the first incumbent, Gerard Baldwin Brown, took up his post the following year. Thus, as one of his successors, Giles Robertson, explained in his inaugural lecture of 1972, the Watson Gordon Professorship can 'fairly claim to be the senior full-time chair in the field of Fine Art in Britain'.

The annual Watson Gordon Lecture was established in 2006, following the 125th anniversary of the chair. We are most grateful for the generous and enlightened support of Robert Robertson and the R. & S.B. Clark Charitable Trust (E.C. Robertson Fund) for this series which demonstrates the fruitful collaboration between the University of Edinburgh and the National Galleries of Scotland.

The ninth Watson Gordon Lecture was given on 6 November 2014 by David Bomford, Director of Conservation, Museum of Fine Arts, Houston. Unfinished paintings can be seen in many of the world's great collections; what circumstances left them incomplete? What do they tell us about the way that painters worked? How do we define 'finish', and when did an artist consider a work to be finished? Such intriguing questions are considered in David Bomford's exploration of the non finito from the Renaissance to the twentieth century.

RICHARD THOMSON
Watson Gordon Professor of Fine Art,
University of Edinburgh

SIR JOHN LEIGHTON
Director-General,
National Galleries of Scotland

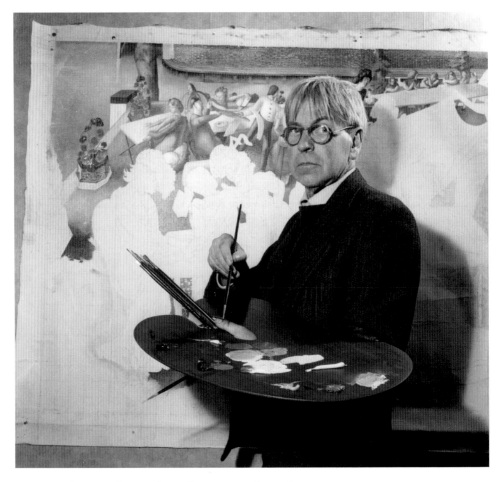

FIG.1 | *Sir Stanley Spencer (1891–1959), at work on* Dinner on the Hotel Lawn, *the fourth in his 'Cookham Regatta' series, c.1956*
Photography by John Pratt, Getty Images

UNFINISHED PAINTINGS: NARRATIVES OF THE NON FINITO

There is a photograph of the English painter Stanley Spencer (1891–1959), observing us with his famous quizzical glance, at work on his 1956/7 *Dinner on the Hotel Lawn,* part of the Cookham Regatta series painted at the end of his life (Chamot *et al.* 1964) (fig.1). In the work in progress, seen behind him, painted sections are fully completed before others are even started – the blank outlines of foreground figures prominently await even their basic drawing lines. Laying in the background first, as the artist is doing here, is a standard practice in figure painting – so that the foreground figures literally overlap and appear to stand in front of the scene behind.

This painting, of course, went on to completion and it is only through the medium of photography that we are able to see it in its unfinished state. But what of paintings that never were completed? In fact, the principal, large canvas of Spencer's series, *Christ Preaching at Cookham Regatta,* was not completed before his death in 1959 and it remains to this day barely half-finished, whole sections still mysteriously blank, exhibited in the Stanley Spencer Gallery, Cookham – the village where he lived and worked (McCarthy 1997).

In this lecture, I want to look at examples of unfinished paintings and consider various notions of what art historians and connoisseurs lump together under the term *non finito* (not finished). In doing so, we encounter some of the strangest images in art – images that are intriguing on so many levels and that raise questions whose answers we might only begin to guess at. In some cases a clear narrative emerges – but too often we are left searching for explanations; and, in that search, the essential nature – the very business – of the painter at work, is brilliantly illuminated in an extraordinary range of dazzling snapshots of art in the making. We are looking over the shoulder of the artist at a moment in time – the unanticipated moment when work stopped and never restarted.

In an unfinished painting, the creative process is for some reason suspended, forever tantalisingly incomplete – just as it is in *The Virgin and Child with Saint*

Andrew and Saint Peter from the workshop of Giovanni Battista Cima (1459–1517) (perhaps, it has been suggested, by his follower Girolamo da Udine) (Humfrey 1983) (fig.2). Whoever painted it, there it hangs in the gallery, mysterious, enigmatic, unexplained except for the terse but accurate description 'unfinished'.

So what are we looking at? Actually, viewed as an Italian panel painting of about 1500, it all seems pretty straightforward: a poplar panel and layers of white gesso, normal for the period and the artist, a drawing typical of Cima's workshop style and a few arbitrarily painted passages of flesh, drapery and background. The four figures – strikingly uninterested in each other, and seemingly pieced together as a group from existing Cima prototypes – vary in completion from almost finished to sketched-in but totally unpainted. The hill town is blocked in with geometric shapes and diagonal hatching and the prominent tree remains a curling, linear form against the dark hillside and the white sky.

Some of the paint – perhaps the blue-grey sky at the upper left – may have been added later, but we cannot be sure. What is certain, however, is that the composition was abandoned and left only partially completed – and, as we will with many of the examples in this lecture, we are bound to ask: why? What happened? What caused this abandonment?

The honest answer is that we have no idea – but we can hazard a few guesses: a cancelled commission? An unsuccessful project that ran into difficulties and was not pursued? A practice exercise in copying Cima motifs? A workshop demonstration piece, deliberately left with its layers showing? All these are possible. In truth, judged by the beautiful technique of Cima's best works, it is a rough, battered, slightly clumsy piece of panel painting. But it commands attention by its very strangeness; it intrigues and fascinates, and viewers are drawn to it, even in a gallery full of more distinguished paintings.

We are reminded of an early and famous remark on the *non finito*, made by Pliny in his *Natural History*: 'unfinished paintings are held in greater esteem than finished works: for in these, the sketch-lines remain and the actual thoughts of the artist are visible – and even as one is charmed by their excellence, there is a sadness that the artist's hand was stilled as he was working on the picture' (Pliny 77–79 AD; McHam 2013).

[8]

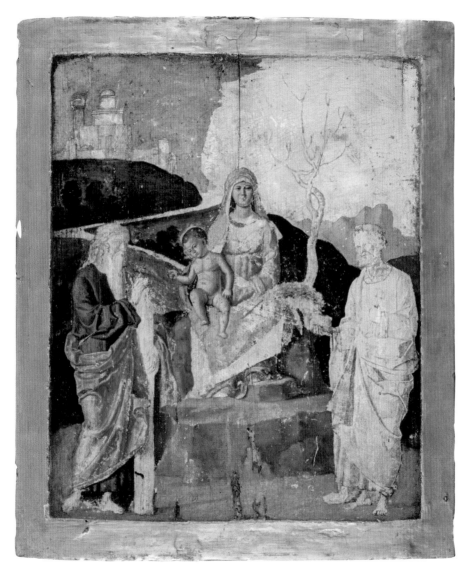

FIG.2 | GIOVANNI BATTISTA CIMA DA CONEGLIANO (FOLLOWER OF)
The Virgin and Child with Saint Andrew and Saint Peter, late fifteenth or early sixteenth century
Oil on panel 47.7 × 39.7cm
Scottish National Gallery, Edinburgh; Presented by Miss Margaret Peter Dove 1915

So how do we measure our reaction to a painting like this? Is it, as Pliny first indicates, merely technical – the pleasure of (as it were) witnessing an artist at work, the revelation of the painter's methods layer by layer? There is no denying that looking at unfinished works uniquely illuminates the study of painting techniques and beautifully clarifies the sense and order of a painter's working process. But Pliny suggests much more than that. Implicit within his 'sadness' at artists failing to complete their works is the key question we have already asked – why? What happened? What were the circumstances that stilled the artist's hand?

The National Gallery, London owns two notable examples of the *non finito* – both panel paintings attributed to Michelangelo (1475–1564) in his early Rome period – *The Virgin and Child with Saint John and Angels,* the so-called '*Manchester Madonna*', is named after its first public appearance in the great Art Treasures exhibition in Manchester in 1857 (fig.3) and the *Entombment* (fig.4) (Hirst and Dunkerton 1994). As we look at the two images, with their missing, blank, unpainted sections, it is worth noting the sense of dislocation that they convey. In these flat paintings, the obvious lacunae undermine the illusion of three-dimensional form. Paintings attempt to represent reality, to create an illusion of the world in depth, by long-established artificial conventions on a two dimensional surface. And it is part of the fundamental nature of this illusion that it only works if it is complete. As soon as the composition is interrupted in some way, the illusion collapses and we register that we are, after all, merely looking at colours assembled on a flat plane. More than any other art form, unfinished paintings retain their power to disturb us and challenge our accustomed ways of reading or responding to coherent picture surfaces.

This is quite unlike an incomplete three-dimensional sculpture, in which our eyes will almost automatically extrapolate into real space and mentally reconstruct the missing part. Consider, for example, the famous unfinished *Slaves* or *Prigioni*, also by Michelangelo, whose name is, of course, almost synonymous with uncompleted artistic projects (Schultz 1975). Many viewers have observed that, to compensate for their incompleteness, our imaginations take over. We see these figures – in some parts hardly begun beyond a rough shaping by assistants – as literally imprisoned within their blocks of stone – just waiting for the sculptor to

reveal and uncover them. Our minds extrapolate the small amount of completed carving into the rough interior of the stone and picture the perfect form waiting to be released. In the blank areas of an unfinished painting, however, notional space is literally absent and the function of the whole is subverted.

The 'Manchester Madonna' was painted about 1497, when a poplar panel – almost certainly this one – is documented as having been purchased by Michelangelo (Hirst and Dunkerton 1994). The painting depicts the Virgin and Child with St John and four angels, and is progressively more finished from left to right across the panel. The two angels on the left are indicated by no more than their outlines and the green underpaint for the flesh tones. The Virgin awaits her hair and the blue of her cloak, so far only undermodelled in black. But the rest of her figure, together with the two boys and the youthful angels at the right studying their scroll, is highly finished – in the finely worked, burnished, luminous – and by then somewhat archaic – technique of egg tempera.

The Entombment was painted only three or four years later, about 1500, in the radically different oil technique – and the colours have the denser, saturated quality the oil medium imparts (Hirst and Dunkerton 1994). Like the 'Manchester Madonna', it was painted in sections – but there is much more variation in the degree of finish from area to area. Some parts are fully worked up, others are undermodelled to some extent, while others have not been started. The kneeling Mary at the lower left has a completely unpainted arm, although her face and neck are almost finished. Other figures are variously part-completed, with missing hands, and dimly modelled faces. Joseph of Arimathea's finished head is set against his unpainted cloak. At the upper left, an empty area behind St John's shoulders was intended for water and, at the upper right, the striking silhouette of two figures lifting the slab of the tomb consists solely of the white gesso ground left as a bare angular shape within the dark paint of the rocky landscape. Most importantly of all, the figure of the swooning Virgin in the foreground was never begun and she exists only as a rough outline around faintly tinted blank gesso at the lower right.

In both the Entombment and the 'Manchester Madonna', the painter clearly intended to develop each discrete area before moving on to the next – much in

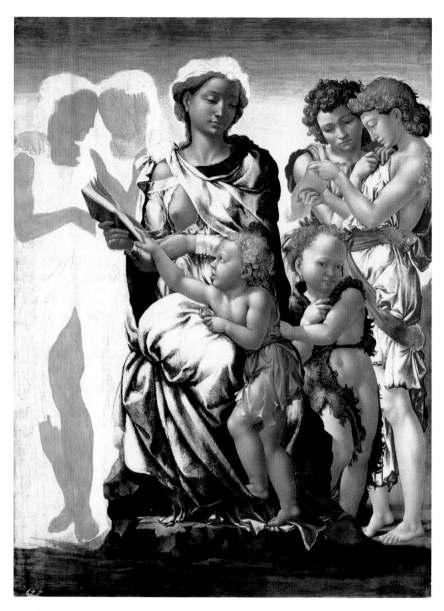

FIG.3 | MICHELANGELO BUONARROTI (1475–1564)
The Virgin and Child with Saint John and Angels (Manchester Madonna), c.1497
Tempera on wood 104.5 × 77cm
National Gallery, London

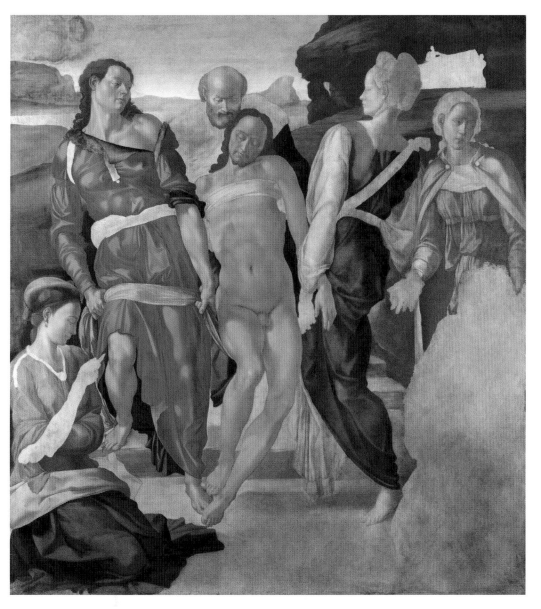

FIG.4 | MICHELANGELO BUONARROTI (1475–1564)
*Entombment, c.*1500
Oil on wood 161.7 × 149.9cm
National Gallery, London

the manner of a fresco painter, as if completing separate *giornate* (a day's work) on successive days' applications of wet plaster. It is comparable to the method employed in the more-or-less contemporary Edinburgh *Virgin and Child with Saint Andrew and Saint Peter*. But contrast the piecemeal technique evident in these paintings with another unfinished work, Raphael's (1483–1520) *Virgin and Child with the Young Saint John the Baptist ('The Esterházy Madonna')* (fig.5), left incomplete when Raphael departed from Florence for Rome in 1508 (Kárpáti and Seres 2013). This painting – curiously pale and bland in appearance – lacks its final modelling layers, but has been worked up gradually and evenly across the surface in a manner much more typical of oil painting in the first decade of the sixteenth century. Even though it is far from finished, the Raphael is an altogether less disquieting image: it has a semblance of completeness because the entire composition has been mapped out and developed consistently. The *non finito* manifests itself here quite differently to the other examples we have seen.

In searching for explanations of the *non finito*, we rapidly find ourselves caught in the cross-currents of historical fact (or, at least, speculation) and critical theory. There are often, of course, straightforward causes of unfinished works: the death of the artist is clearly the most obvious, and there are numerous examples of that, some of which will be mentioned later. That, however, clearly cannot be the explanation for these incomplete paintings by the young Michelangelo – poignant forerunners of the *Slaves* and a whole series of projects that he later abandoned. It has been suggested that the execution of the two panels was delayed while Michelangelo waited for the delivery of lapis lazuli fine enough for the painting of the Virgin – a plausible enough theory given that her robe awaits its blue glaze in one painting and she is entirely absent in the other. The generally accepted hypothesis, though, is that – even as he painted – Michelangelo's mind was firmly fixed on sculpture projects. Completion of the St Peter's *Pieta* in 1498 certainly intervened – and, by the summer of 1501, he was in Florence taking possession of the huge block of marble that was to become the giant *David*, leaving his unfinished paintings behind him in Rome. Shortly afterwards, he is documented as repaying money received from the friars of Sant' Agostino for a painting – never completed – for a chapel dedicated to the Pieta: it

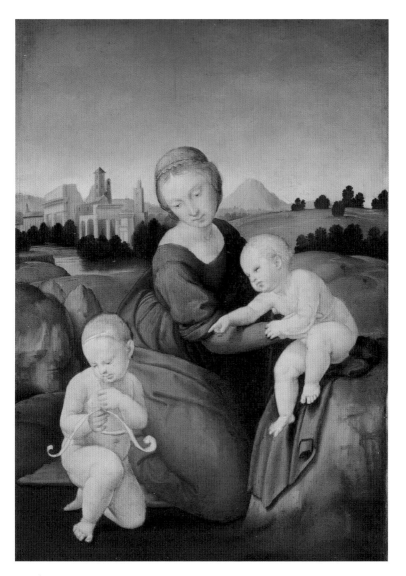

FIG.5 | RAPHAEL (RAFFAELO SANTI) (1483–1520)
Virgin and Child with the Young Saint John the Baptist (The Esterházy Madonna), c.1508
Tempera and oil on wood, 28.5 × 21.5cm
Museum of Fine Arts, Budapest

has been convincingly argued that that painting was this *Entombment* (Hirst and Dunkerton 1994).

But we cannot ignore the underlying pattern here. Running alongside such plausible historical narratives of the *non finito* is a whole body of critical discourse, framed in broadly Neoplatonic terms, that places a more profound interpretation on the chronic inability of Michelangelo to finish his works – and, indeed, of Leonardo da Vinci (1452–1519), in such paintings as his *Adoration of the Magi*, commissioned by the Augustian monks of San Donato a Scopeto in Florence in 1481, but left unfinished when Leonardo departed for Milan the following year.

Giorgio Vasari offered similar justifications for both artists, based on the potentially unbridgeable gulf between conception and execution. Of Michelangelo he said (and this is the essence of the Neoplatonic argument) 'his powers of imagination were of such a kind and so perfect that he often abandoned his works, because he could not express with his hands the grand and terrible conceptions that he had in his mind' (Vasari [*Life of Michelangelo*] 1550). Vasari also introduced the idea of the unfinished work as a notional short cut to perfect form, largely avoiding the troublesome business of manufacture. Speaking of the sculpture we have already seen, he said, 'although it remained unfinished, having been roughed out and showing the marks of the chisel, in the imperfect block one can recognise the perfection of the completed work.' We shouldn't forget, however, that Michelangelo was perfectly capable of completing sculptures to the highest finish – and paintings too, such as the flawless, glowing *Doni Tondo* of 1504–6.

Vasari's exasperation with Leonardo and Leonardo's with himself are well known. After saying 'Leonardo, with his comprehension of art began many things and never finished one of them', Vasari offered the usual Neoplatonic explanation: 'It seemed to him that the hand could never achieve the perfection or purpose that he had in his thoughts or beheld in his imagination.' Vasari memorably ended his *Life of Leonardo* by reporting the famous deathbed scene in which the artist confessed and repented that he had offended God and Man by not working at his art as diligently as he should have done (Vasari [*Life of Leonardo*] 1550).

Issues of the *non finito* in Michelangelo and Leonardo have been extensively

discussed in the literature and it is not my intention to review them again here. Rather, I would like to range across the centuries to throw light on a variety of unfinished paintings that raise questions about artistic process and circumstance.

Before we leave the Neoplatonic notion of the disjunction between concept and practice, let us look at a particularly telling example of an artist's failure to resolve a composition and the necessity of beginning again. Andrea del Sarto's (1486–1530) *Sacrifice of Isaac* is clearly unfinished, with large sections of pale ground and underdrawing visible in the figures and animals at the right (fig.6). The paint layers in many other areas have hardly progressed beyond a vigorous freely brushed underpainting. The angel is a wild confusion of unresolved *pentimenti* (changes made by the artist during the process of painting) as Andrea tried out different positions and it is at this point that he seems to have given up. Two other, finished, versions followed (now in Dresden and Madrid) in which the awkward group at the right was shifted around, the angel found a more considered pose and the draperies and flesh tones were fully worked up (Shearman 1965). Andrea clearly eventually resolved the composition to his satisfaction, but what is striking is the loss of freedom and spontaneity in the brushwork of the later versions: the manifest appeal of the unfinished manner is lucidly illustrated by the successive states of this work.

An explanation for the unfinished state of Rosso Fiorentino's (1494–1540) *Allegory of Salvation with the Virgin and Christ Child, St. Elizabeth, the Young St. John the Baptist and Two Angels* (fig.7) – in which the bright yellow imprimatura is left uncovered in many places – is less easy to identify (Franklin 1994). It might be due to Rosso's extensive travels at this period, or the death of his patron, but perhaps a previous episode of doubt and rejection in which he was involved could be relevant. Vasari records how an earlier patron, Leonardo Buonafé saw a commissioned work (the *Santa Maria Nuova* altarpiece now in the Uffizi) at the underpainting stage and disliked so much 'the saints with their savage and desperate air, who appeared to him like devils' that he refused to accept it (Franklin 1987). Maybe the angular harshness and sickly colouring of the figures in the Los Angeles painting too were so unappealing to a potential patron that it was rejected and abandoned.

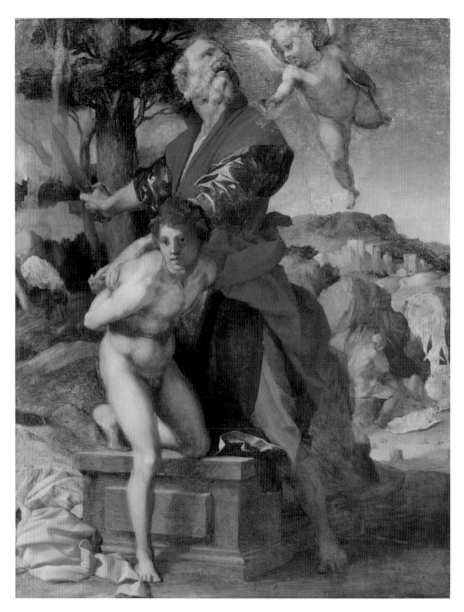

FIG.6 | ANDREA DEL SARTO (1486–1530)
*Sacrifice of Isaac, c.*1527
Oil on wood framed 208 × 171cm, unframed 178 × 138cm
The Cleveland Museum of Art, Cleveland

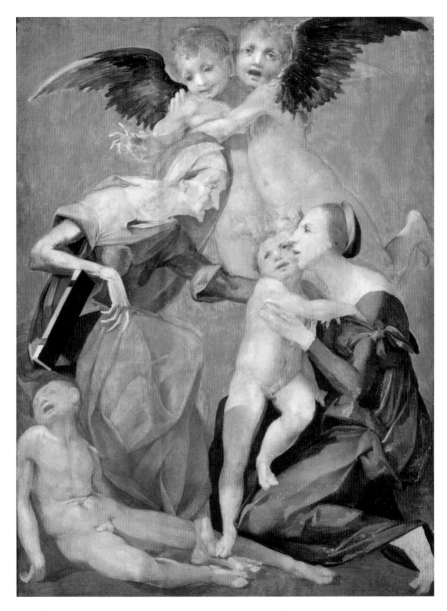

FIG.7 | ROSSO FIORENTINO GIOVANNI BATTISTA DE JACOPO (1494–1540)
Allegory of Salvation with the Virgin and Christ Child, St. Elizabeth, the Young St. John the Baptist and Two Angels, c.1521
Oil on panel 161.29 × 119.38cm
Los Angeles County Museum, Los Angeles; Gift of Dr and Mr. Herbert T. Kalmus

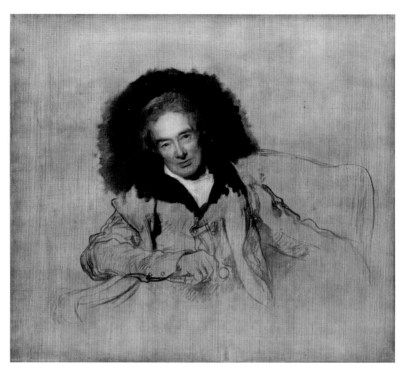

FIG.8 | SIR THOMAS LAWRENCE (1769–1830)
William Wilberforce, 1828
Oil on canvas 96.5 × 109.2cm
National Portrait Gallery, London; Given by executors of Sir Robert Harry Inglis, 2nd Bt, 1857

But let us return to the simplest narrative of the *non finito*: the most obvious place to look for unfinished paintings is in the studio or workshop after the death of an artist. What we find there are both final works in progress, and earlier works set aside and left uncompleted. Of the many examples we could choose, three from the nineteenth century will suffice. First, the portrait of William Wilberforce, which was commissioned from Sir Thomas Lawrence (1769–1830) in 1826 and left unfinished at Lawrence's death (fig.8). Second, the delightfully sentimental *Poor Actress's Christmas Dinner* by Robert Braithwaite Martineau (1826–1869) (fig.9) famous for his moralising Victorian narrative pictures such as *The Last Day in the*

FIG.9 | ROBERT BRAITHWAITE MARTINEAU (1826–1869)
*Poor Actress's Christmas Dinner, c.*1860
Oil on canvas 36 × 47cm
Ashmolean Museum, Oxford; Presented by Miss Helen Martineau, 1941; WA1941.61

Old Home (1862): the unfinished picture shows his normally intricately finished and polished technique in its broadly laid-in early stages. In both paintings, the sequence of working – freely brushed outlines followed by the working up of principal details – is clearly visible.

Third, the Victorian painter Ford Madox Brown (1821–1893) worked on his creepily ambivalent *Take your Son, Sir* over many years and it remained conspicuously unfinished in his studio when he died (Hackney 1982) (fig.10). He began it in 1851 as a small head-and-shoulders portrait of his second wife Emma, enlarging it in November 1856 to add their ten-week-old son. He clearly intended

[21]

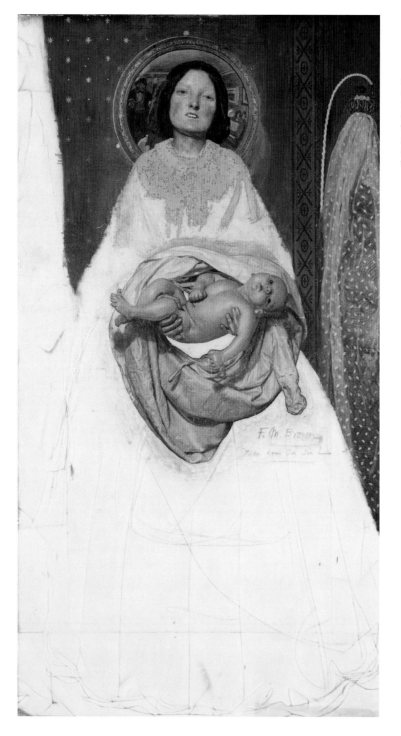

FIG.10 | FORD MADOX
BROWN (1821–1893)
Take your Son, Sir, 1851–92?
Oil on canvas 70.5 x 38.1cm
Tate, London; Presented by
Miss Emily Sargent and Mrs
Ormond in memory of their
brother, John S. Sargent

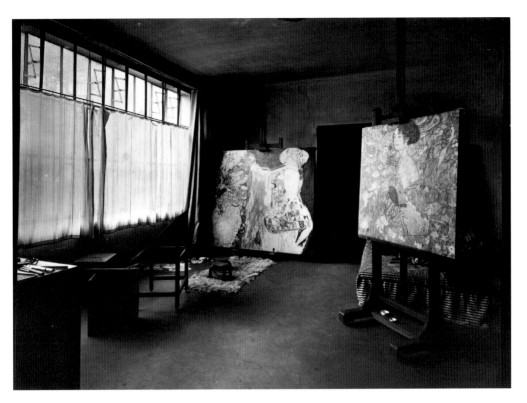

FIG.11 | *The Last Studio of Gustav Klimt in Vienna, 8th district,*
Feldmuehlgasse 11, with two unfinished paintings, 1918
Photography by Imagno, Getty Images

to transform it into a full-length, but went no further with it – perhaps because of its fatal, unresolved ambiguity. Is it a celebration of marriage and motherhood in Victorian society – or a scene from contemporary life in which a kept woman offers her illegitimate child to its leering father, glimpsed in the mirror behind? In fact, Brown and Emma's son, depicted here, died aged ten months, so it is more likely that, in his grief, Brown simply couldn't bring himself to finish it. While it is obviously fascinating as a half-finished painting, it becomes especially so when we learn that it was acquired from Brown's family by the painter John Singer Sargent for his own collection; after Sargent's death, it passed to the Tate Gallery.

The demise of artists can also be expressively captured by recording their

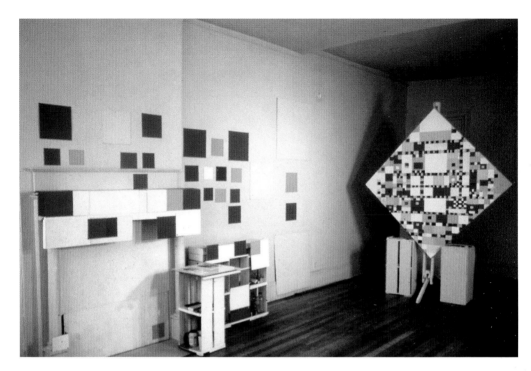

FIG.12 | *Mondrian's 15 East 59th Street Studio, after his death*
Photography by Harry Holtzman, 1944
Modrian/ Holtzman Trust

absence: two well-known photographs of artists' studios from the twentieth century speak touchingly of the recent departure of their inhabitants. First, that of Gustav Klimt (1862–1918) after his death, with two unfinished works visible, *The Bride* and *Lady with Fans* still on their easels (fig.11) – and, second, Pieter Cornelis Mondrian's (1872–1944), in New York in 1944, looking rather cleaned up and containing his last work *Victory Boogie Woogie*, its design of interlocking squares and rectangles on a diamond format largely mapped out but awaiting colour in many parts (fig.12). *Victory Boogie Woogie* is a fascinating case. Mondrian was in the middle of reworking it when he died, and the surface was covered with strips and patches of coloured tape, originally held in place by thumb tacks – standing in for the colours of paint he was about to apply. As *Victory Boogie Woogie* was subsequently moved around, some of the pieces fell off and were lost; but most

[24]

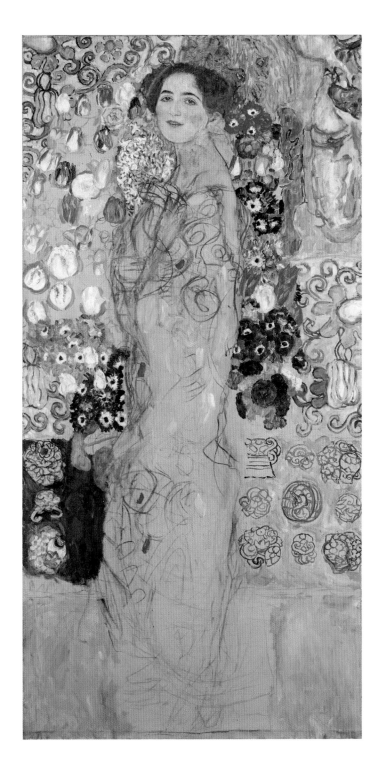

FIG.13 | GUSTAV KLIMT
(1862–1918)
Posthumous Portrait of Ria Munk III,
1917–1918
Private collection

of them survived – and today you can see multiple fragments of roughly cut, coloured tape, curling at the edges, piled up, superimposed, on the surface of the work – a vivid, evocative reminder of the revisions the artist was contemplating immediately before he died.

The two Klimt paintings we saw in his posthumous studio were among a number of works left unfinished by his sudden death, aged 55. They form a clear group, revealing his technique of underdrawing and painting with startling clarity. As we know from the drawings, his control of line and form is breathtakingly sure and fluent. The portrait of Ria Munk (fig.13), with extensive passages simply roughed out, was Klimt's third, uncompleted attempt to capture a likeness of the 24-year-old who had committed suicide after an unhappy love affair in 1911 (Natter 2012). It was a commission from her parents who wanted to commemorate her and they took possession of the painting in this state. The poignant combination of dead girl, dead artist, grieving family and unfinished painting seems to sum up rather perfectly that quintessential Viennese melancholy that hung over the city in the early twentieth century.

Klimt's grandest unfinished portrait was of Amalie Zuckerkandl (fig.14), commissioned as early as 1913/14, but held up by the sitter's absences from Vienna as a nurse in the First World War (Natter 2012). When she returned, Klimt was able to resume work on it, but only completed her head and shoulders before he died. The rest is indicated in outline on the pale brown priming. Amalie took possession of the unfinished picture and it stayed in the family until it was given to the Osterreichische Gallery in the 1980s; she herself had a tragic end, murdered in Belzec concentration camp during the Second World War.

If we go further back in time, there are numerous accounts and records of artists' workshops stacked with uncompleted works when they died. El Greco (1541–1614), for example, left at least twenty unfinished portraits at his death. What remained in artists' studios when they died was the subject of some remarkable research carried out by Linda Bauer of the University of California at Irvine. Professor Bauer compiled a huge amount of information on artists' estates from wills and inventories – and the statistics are sometimes extraordinary (Bauer 1987). An inventory of 1529, for example, tells us that Palma Vecchio (1480–1528)

FIG.14 | GUSTAV KLIMT (1862–1918)
Amalie Zuckerkandl, 1917–1918
Belvedere, Vienna

left twenty-eight unfinished pictures and describes the exact state of finish of each one. Jacopo Bassano (1510–1592) left sixty incomplete paintings; Sebastiano del Piombo (c.1485–1547) seven.

But we can have absolutely no conception of the sheer scale and mechanisation of the seventeenth century art market until we read the inventory of the now almost completely unknown painter Nicolao Ventura whose possessions were sequestered in Rome in 1616. In his workshop were 767 paintings, both finished and unfinished, of which 324 were portraits or heads, 110 were popes, princes, cardinals, philosophers or saints and 128 were poets and Turks. In 1673, we find an inventory which exceeds even that: Mario de Fiori left 800 paintings of which 100 were unfinished, including five portraits of cardinals described as *senza testa* (without heads) – presumably to be completed with a likeness when the next cardinal client came along (Bauer 1987).

The obvious question is: whatever happened to all those paintings left by dead painters? Were they lost, or were they subsequently finished by other hands? It would seem highly likely that they were not wasted – that they were handed over to other artists who completed them. We certainly know of celebrated works that were. Pesellino's (c.1422–1457) *Trinity Altarpiece* left unfinished at his death was completed by Filippo Lippi (c.1406–1469) and was the subject of litigation by Pesellino's widow, disputing how much of the final payment was owed to her for her late husband's work (Gordon 2003). And Raphael's *Transfiguration*, commissioned in 1517 for Narbonne cathedral but still incomplete at his death in 1520, was finished by Giulio Romano (c.1499–1546) and Giovanfrancesco Penni (1496?–1528) (Oberhuber 1999).

Unfinished paintings can be the most startlingly vivid snapshots of an event or moment in time: occasionally, if the historical narrative permits, they illuminate our precise knowledge of why the artist stopped work, stepped away from the picture and laid down the brush.

With Benjamin West's (1738–1820) *American Commissioners of the Preliminary Peace Negotiations with Great Britain ('Treaty of Paris')* (fig.15) we know exactly what was going on (Von Erffa and Staley 1986). In 1783, the American Revolutionary wars were ended by negotiations in Paris between the American

and British delegations, and West set up his easel to record the event. He began painting the likenesses of the Americans, John Jay, John Adams, Benjamin Franklin, Henry Laurens and William Temple Franklin, but the British delegation refused to pose. This is probably quite understandable, since they had just given away huge swathes of territory and were no doubt sore losers: but the result was that West was unable to persuade them and the painting remained uncompleted, the figures intended for the right side of the composition entirely missing. It is both a dramatic historical document of an ill-tempered occasion and a wonderful demonstration of West's painting technique, with its fluent brush drawing of the main outlines and shadows on a warm coloured priming, followed by the laying-in of the basic colours.

But Benjamin West's difficulties pale into insignificance compared with the tempestuous experiences of another, earlier artist whose unfinished works conjure up the whole tumultuous era in which he lived: Jacques Louis David (1748–1825) and his turbulent career through the Revolution in France (Brookner 1980). Perhaps his most famous unfinished picture is his first portrait of Napoleon, begun at Napoleon's request in 1798. They were together for just a few hours on that occasion and David only had time to paint the head in a marvellously direct and challenging pose (fig.16). They were not to meet again until after Napoleon's Egyptian expedition.

Five years before, during the Terror, as a fanatical member of the Committee for General Security, David had signed nearly 300 arrest warrants and about 50 summonses to appear before the Revolutionary Tribunal, which led almost inevitably to the guillotine. To his credit, he also signed a number of release orders and helped artists and other friends to avoid execution – but, nevertheless, his ruthlessness at that time is a notorious stain on his character. His loving wife divorced him because of it – although she later re-married him when the madness had abated.

He was painting pictures all through the Revolutionary period – and it is hardly surprising that he failed to complete a number of them. A notable unfinished project was the gigantic canvas of the *Tennis Court Oath* of which only half survives at Versailles, with just four completed heads and bodies drawn in the

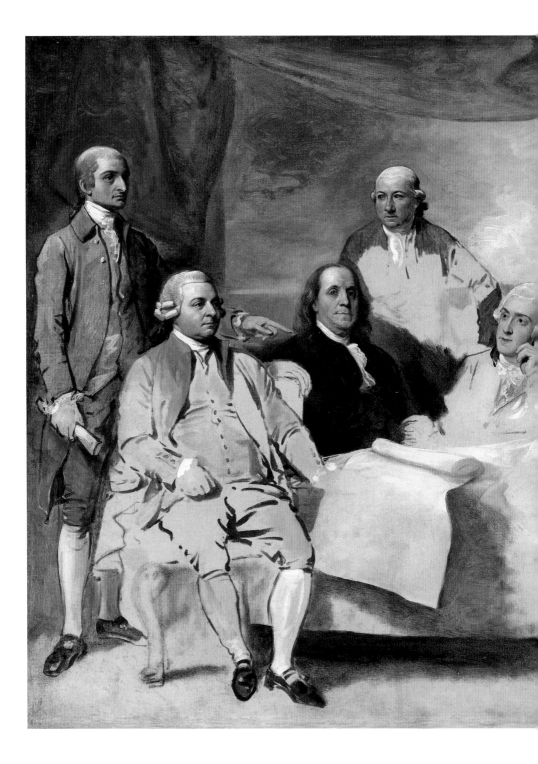

FIG.15 | BENJAMIN WEST
(1738–1820)
American Commissioners of the Preliminary
Peace Negotiations with Great Britain, 1783
Oil on canvas 72.3 × 92.7cm
Winterthur Museum, Wilmington; Gift of
Henry Francis du Pont

nude – although they would have been clothed in the completed painting. The composition was to have had '1000 figures in the most energetic attitudes' and David began painting it in 1791, but he soon set it aside and definitively abandoned it in 1801, disillusioned and busy with other projects.

Several single portraits also remain unfinished from the 1790s. It would be historically satisfying to find one that was left uncompleted because David sent its sitter to the guillotine – and one portrait was long thought to be just such an example (fig.17). It used to be identified as the daughter of the painter Joseph Vernet (1714–1789), Madame Chalgrin, who was guillotined in 1794 (Brookner 1980). The legend of David's deliberate non-intervention in her death – the painter faithful to Truth but not to Justice – made the painting famous.

Alas for the legend, it turned out not to be Madame Chalgrin at all, but Madame Charles-Louis Trudaine (Louvre 2015). She was indeed close to tragedy – her husband and brother-in-law, an old friend of David's, were guillotined, but she wasn't. Although David cannot be directly linked to their deaths, he certainly did nothing to protect them. Painted around 1792, the portrait is notable for the wild-haired, electrifying gaze that the sitter directs at the viewer and for the fact that it is obviously unfinished. It has a brilliant sketch-like quality – barely more than a broadly stippled underpainting with pale priming visible everywhere. This was David's habitual way of setting down his portraits and such vigorous dabbed underlayers are present beneath all his highly finished portraits.

The same brilliant vibrating underpaint is visible in another portrait – that of Madame de Pastoret, also painted in 1792 (Brookner 1980). Madame de Pastoret is shown (fig.18) sewing next to a cradle containing her son, who grew up eventually to become a senator in the second empire. Due to the unfinished state, her needle and thread have not yet been painted in. The portrait remained uncompleted because Madame de Pastoret was imprisoned during the Terror, but survived (we are told) to lead a worthy life in charitable education.

The famous portrait of Madame Recamier by David is also traditionally considered unfinished, but more from the narrative that surrounds it rather than its appearance, which is not conspicuously incomplete. It has a stippled technique a little more finished than the Trudaine and Pastoret portraits, but still not as

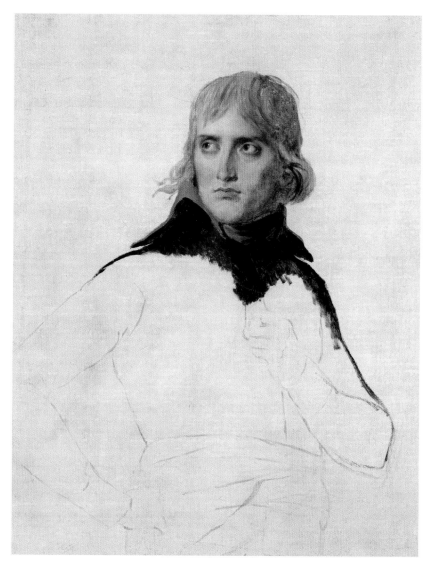

FIG.16 │ JACQUES LOUIS DAVID (1748–1825)
Napoleon, 1798
Oil on canvas 81 × 65cm
Louvre, Paris

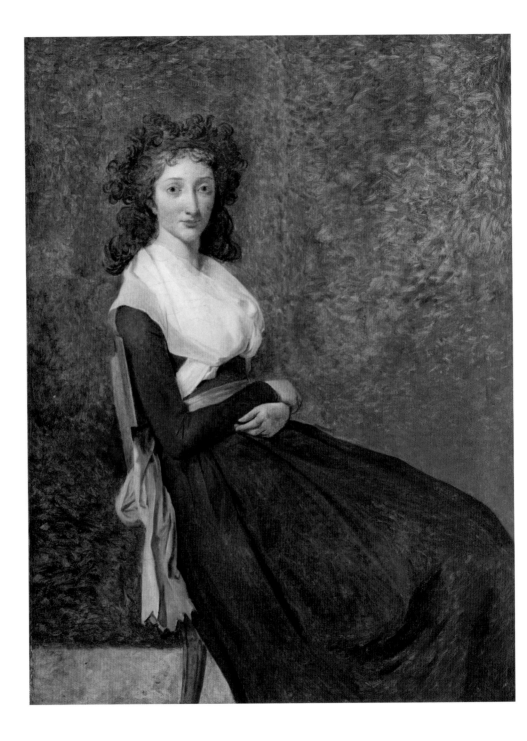

smoothly worked as his most polished handling. The story here is that Juliette Recamier, one of the most dazzling beauties of her age, disliked the business of posing for David so much that she commissioned another portrait from his pupil Gerard. Eventually David became so irritated that he wrote to her, 'Madame – ladies have their caprices and so do artists. Allow me to indulge mine. I will keep your portrait in its present state' (Brookner 1980). And we must assume that that is precisely what he did and that he never fully completed it.

In the light of a painting like *Madame Recamier* in which completion is a matter of degree and perception, we must now address the whole question of what we mean by 'finish'. What does the idea of finish mean to an artist? Is a brilliant, flickering, freely brushed Barbizon picture by Théodore Rousseau (1812–1867) a finished work, a sketch, an aide-mémoire? The truth is, it doesn't matter: it had long since ceased to be a relevant question. Painters like Rousseau, Charles-François Daubigny (1817–1878), Jean Désiré Gustave Courbet (1819–1877) and then the Impressionists deliberately challenged conventional ideas of finished paint surfaces and irrevocably blurred the distinctions between finish and non-finish. For reference, there are several truly unfinished Monets, found in the Giverny studio and now in the Musée Marmottan, Paris, some bearing the estate stamp, some no name at all. With these, we are looking at the rapid preliminary layers, the scrubbed underpainting, of familiar compositions of the Seine and of Charing Cross Bridge, each one the work of an hour or less – each one intended to receive more layers of paint on these bare bones (House 1988). But how much more paint? Perhaps a few swirls of colour, as in his extraordinary, vaporous versions of Charing Cross Bridge, also set aside, also unfinished, also unsigned? Or more systematic working-up as in the more substantial versions, dated and signed? Signed-off: the presence of the signature declares that un-finished has become finished – that the work of brushing paint on canvas has been completed to the artist's satisfaction. But deciding when he had reached that point was not easy for Claude Monet (1840–1926), who said, 'while adding the finishing touches to a painting might appear insignificant, it is much harder to do than one might suppose'.

If the Impressionists redefined notions of finish, then Cézanne's (1839–1906)

FIG.17 | JACQUES LOUIS DAVID (1748–1825)
Madame Charles-Louis Trudaine, 1792
Oil on canvas 130 × 98cm
Louvre, Paris; Bequest of Horace Paul Delaroche

paintings can be even more ambiguous: much attention has been given to the un-finish of many of his landscapes, still-lives and portraits – most importantly the catalogue of a landmark exhibition entitled 'Cézanne – Finished, Unfinished' which took place in the Kunsthaus Zurich in the year 2000 and brought together an unprecedented number of his later works. Painting on stark white primings, Cézanne consciously left large areas unpainted, so that, in between the elements of the composition, we are looking at … what? White light? The picture plane? Abstract space? The very atmosphere that envelops everything? By any conventional definition of painting, these are wildly, wilfully unfinished – but in all of them, Cézanne arrived at a point of equilibrium between paint and emptiness that perfectly satisfied him – that anything more, any further brushstrokes, any extra colour, would unbalance, destroy. In a letter, he wrote of this tension between pictorial convention and what he was observing: 'Now being old … in my case sensations of colour, which give light create abstractions that prevent me from covering my canvas or from pursuing the delimitation of objects where the points of contact are tenuous and delicate; thus my image or picture is incomplete' (Baumann 2000).

I have ranged backwards and forwards in time, exploring various narratives of the *non finito*, and I want to return one last time to the sixteenth century to explore one of the most vexed questions of all. When we speak of the various concepts of – and indeed the taste for – unfinished versus finished paint surfaces, of the liking for sketchy roughness over academic smoothness, we are inclined at first to think, as we did just now, of nineteenth and twentieth century paint surfaces, the Barbizon painters, the French Impressionists, the German Expressionists. We might think that the taste for quick, painterly techniques and rapid brushwork is a relative modern sensibility – but we know that the aesthetic appeal of rough sketchy handling was already fully formed in the sixteenth century. Referring to the initial stages of Titian's working process, the artist and writer Marco Boschini wrote, 'the most sophisticated connoisseurs found such sketches entirely satisfactory in themselves and they were greatly in demand' (Boschini 1674). They were especially prized by other painters: the *Crowning with Thorns* (which we shall see in a moment, and which was described by Boschini as 'an outstanding

FIG.18 | JACQUES LOUIS DAVID (1748–1825)
Madame de Pastoret and Her Son, 1791/92
Oil on canvas 129.8 × 96.6cm
Art Institute of Chicago; Clyde M. Carr Fund and Major Acquisitions Endowment

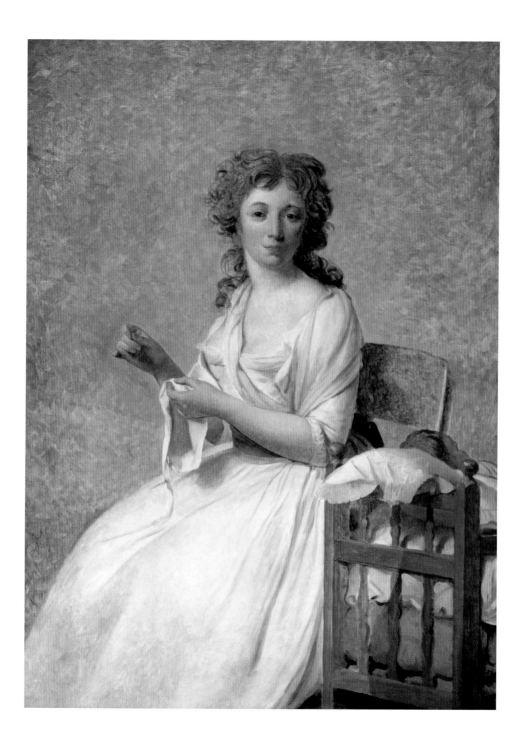

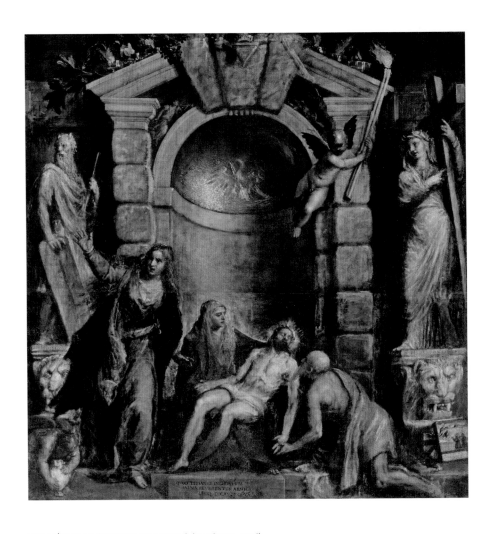

FIG.19 | TITIAN (TIZIANO VECELLIO) (C.1485/90–1576)
*Pieta, c.*1575
Oil on canvas 389 × 351 cm
Galleria dell'Accademia, Venice

unfinished work') was acquired by Tintoretto, with three other late paintings, after Titian's death. Other late Titians were acquired by Rubens for his own collection around thirty years later, including the last self-portrait now in the Prado, Madrid.

Titian's (c.1485/90–1576) *Pieta* (fig. 19) was famously finished after his death by Palma Giovane (c.1548/50–1628) – whose 'humble' (according to Ridolfi 1648) Latin inscription runs along the bottom step – claiming that 'what Titian left unfinished [he uses the word 'inchoatum'] Palma reverently completed' (Pedrocco 2000). Boschini, writing in 1674, stated that the lights and darks are all by Titian but the figures are in many places retouched and covered by Palma. Some have claimed to identify Palma's style in the putto holding the flaming torch at the upper right. In the modern era, Kenneth Clark wrote somewhat regretfully of Palma's intervention, saying 'we cannot blame him, but if it had come down to us as Titian left it, I think it would have been one of the greatest pictures in the world' (Clark 1981).

With this painting, and with the interjection of Clark's opinion, our consideration of the *non finito* enters altogether more complex territory. Most of the examples of unfinished paintings we have looked at so far might all be described as 'art interrupted' or 'art abandoned', and it is true that the *Pieta* was certainly judged incomplete when Titian died. But it also belongs to that category of paintings we group together under the problematic title of 'late Titian'. In the same group we must include the *Death of Actaeon* (London) and the *Crowning with Thorns* (Munich), with their flickering, uneven brushwork and rough, dark, unresolved surfaces – and the extraordinary *Apollo and Marsyas ('The Flaying of Marsyas')* (Kroměříž), with its blizzard of shredded paint strokes.

The question that is always asked of Titian's late works is a deceptively, dangerously, simple one – are they actually, formally, unfinished (Hope 2003)? Arguments are advanced as to whether this painting or that one was delivered to the patron or remained in the workshop. But does the notion of 'finish' have any meaning in this context? It is clear that Titian left his late works in a variety of different states, some more conventionally finished than others. Palma Giovane's famous eye-witness account of Titian at work, quoted by Boschini 1674, vividly describes the almost arbitrary process of building up his paintings on the 'precious

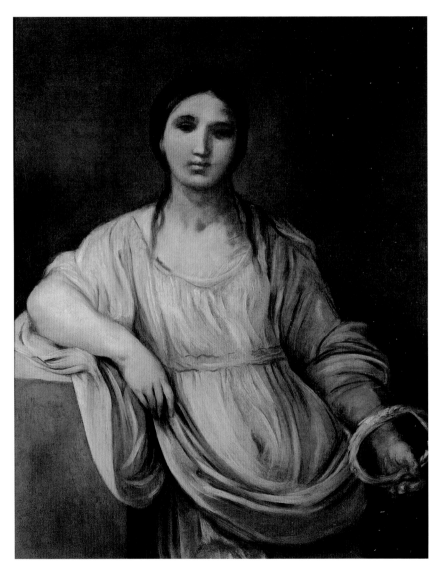

FIG. 20 | GUIDO RENI (1575–1642)
Portrait of a Girl with Crown, 1640–1642
Oil on canvas 91 × 73cm
Musei Capitolini, Rome

foundations' that he sketched out in a 'great mass of colours'. Titian would turn his pictures to the wall and leave them, sometimes for several months. When he looked at them again it was 'as if they were his mortal enemies, to see if he could find any faults' and he would work over them again and again as he thought necessary – in the last stages painting more with his fingers than his brushes.

We are now encountering – and, in conclusion, must consider – the most tantalising question of all relating to finish or unfinish. In one of his last and most moving essays 'The Artist Grows Old', Kenneth Clark (1981) defined what he called the 'old age style', a tendency for certain artists – just a few who lived long enough – to develop an increasingly sketchy, rough, abbreviated unfinished-looking technique. According to Clark, it was characterised by 'a reckless freedom of facture, caused by the painter's feelings of imminent departure – a retreat from realism, an impatience with established technique' (Clark 1981). We can sense Clark's admiration for these aged artists who could pour a lifetime of experience into summoning up flickering, coloured form with just a few touches – the bare minimum of substance and painterly convention. Clark listed some of the artists who, in his opinion, manifested old age style. Titian of course was the prime example, but Clark plausibly identifies it also in the paintings of Rembrandt (1606–1669), Poussin (1594–1665), Claude (1604/5?–1682), Turner (1775–1851), Monet, Degas (1834–1917), Cézanne and, surprisingly, Hokusai (1760–1849).

A more recent book by Philip Sohm (2007), which borrows the exact title of Clark's essay, investigates the old age of painters in great detail and makes a telling distinction – which Clark does not – between 'romantic' (Clark's interpretation) and 'pragmatic' explanations of an old age style. In the latter, we must consider deterioration of faculties, shaking hands, failing eyesight, declining powers – the very real physical handicaps of old age that might affect the look of a painting from a painter at the end of his life. And, equally pragmatically, we must consider the possibility that the painter simply lacked the energy or the stamina or the enthusiasm to finish his works properly.

Such explanations were advanced for the late paintings of Guido Reni (1575–1642), which have often been considered unfinished (Spear 1997). They can have a sketchy paleness, a lack of detail and resolution that seems to speak of the *non*

finito. We can see passages of such vagueness and washed-out colour in paintings such as *Moses with Pharoah's Crown* (Scottish National Gallery) and, even more so in paintings such as *Portrait of a Girl with Crown* (fig. 20) which is likely to be a work only at the underpainting stage. Reni's biographer Malvasia drew attention to his late, 'white' style, attributing it partly to the artist's physical and mental decline to which he adapted with a new delicacy of touch, partly to his chronic gambling habit which distracted him from his work, partly (ingeniously) to his clever foresight in making his paintings pale to allow for the eventual darkening of the oil, and partly to the fact that some pictures were genuinely unfinished.

Old age style may appear different wherever we find it, but it has in common qualities of a daring unorthodoxy of surface, of suggestion rather than detail, of subdued colour, of texture in the service of profound form rather than line or superficial appearance. Are we right to define old age style as a category of unfinished art? Does it even exist? These are questions that scholars of the *non finito* will continue to discuss and disagree over. But it seems to me that Kenneth Clark's romantic, poetic interpretation touches on a truth about artistic lifetimes spent observing, recording, refining, until just some insubstantial essence remains – all that is required to capture the true nature, the shifting appearance of things.

Whatever the truth of that, though, any discussion of finish and the *non finito* inevitably circles back to Titian, the indisputable beginning of this great, complex narrative. He, together with his Venetian contemporaries, authorised a whole new aesthetic in which a sketch-like technique and painterly brushwork fundamentally redefined what constituted a finished painting, and this changed the whole trajectory of European painting. Paradoxically, Titian's look of effortless un-finish could be a slow and painstaking process, achieved sometimes over many months – and this has added to the critical confusion surrounding these works. Vasari, while disapproving Titian's lack of *disegno* (drawing or design), perceptively praised his painterly skills and stressed that they could not be easily emulated: 'this method of painting has caused many artists, who have wished to imitate him and thus display their skill, to produce clumsy pictures. For although many people have thought that they are painted without effort, this is not the case and they deceive themselves ...' (Humfrey 2007). And perhaps a fitting concluding

[42]

FIG. 21 | TITIAN (TIZIANO VECELLIO) (*c.*1485/90–1576)
*Portrait of Pietro Aretino, c.*1545
Oil on canvas 96.7 × 76.6 cm
Palazzo Pitti, Florence

image and epitaph to Titian's technique is his portrait of his friend Pietro Aretino (fig. 21). Aretino's well-known, good-natured complaint was that if you paid the old painter a bit more money, he did a bit more work: yet another possible, pragmatic explanation for the old age style. In this case, that didn't happen – so, as a result, the portrait that we see today – dazzlingly accomplished to the modern eye – was, according to Aretino, 'more sketched than finished' (Ferino-Pagden 2007; Pedrocco 2000).

But let me leave you, finally, with an entirely different category of unfinished painting – that intriguing *jeu d'esprit* (play of the mind) that painters like to play – the unfinished painting-within-a-painting. A favourite is Giovanni Battista Tiepolo's (1696–1770), *Alexander the Great and Campaspe in the Studio of Apelles* (fig. 22), in which the painter Apelles paints Alexander's favourite mistress Campaspe and falls in love with her – whereupon Alexander presents her to Apelles as a reward for the portrait. The unfinished oval portrait with its red-brown priming is seen on a grand studio easel and the painter has just sketched in the head. Tiepolo painted *Apelles and Campaspe,* more than once: there is a smaller, altogether more comical version painted a decade or two earlier, now in Toronto. A wonderfully multi-layered conundrum, playing on the edges of seeming and being with contemporary identity and ancient mythology, the painting shows, as Campaspe, the artist's real-life wife Cecilia Guardi (the daughter of another artist). Apelles himself – turning awkwardly towards us – is Tiepolo's comical self-portrait, and the unfinished picture on the easel is at once a poignant tribute to his beautiful young wife, a meditation on the act of painting and a joyous celebration of the *non finito.*

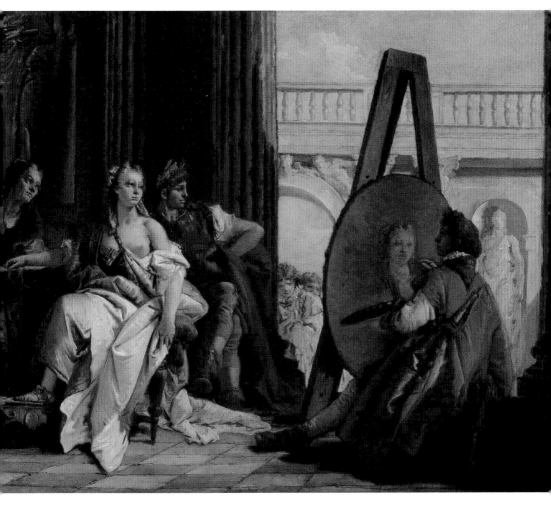

FIG. 22 | GIOVANNI BATTISTA TIEPOLO (1696–1770)
Alexander the Great and Campaspe in the Studio of Apelles, c.1740
Oil on canvas 42.5 × 54cm
The J. Paul Getty Museum, Los Angeles

REFERENCES

BAUER 1987
Linda Freeman Bauer, 'Oil Sketches, Unfinished Paintings and the Inventories of Artists' Estates', in *Light on the Eternal City*, H. Hager and S. Munshower (eds), University Park 1987, pp.93–107

BAUMANN 2000
Felix Baumann, Evelyn Benesch, Walter Feilchenfeldt and Klaus Albrecht Schroder (eds), *Cézanne, Finished – Unfinished*, Zurich 2000, p.53

BOSCHINI 1674
Marco Boschini, 'Breve Instruzione: Tiziano' in *Le Ricche Minere della Pittura Venezia*, Venice 1674

BROOKNER 1980
A. Brookner, *Jacques-Louis David*, New York 1980, pp.105, 109, 145

CHAMOT, FARR AND BUTLIN 1964
M. Chamot, D. Farr, and M. Butlin, *The Modern British Paintings, Drawings and Sculpture*, London 1964

CLARK 1981
K. Clark, 'The Artist Grows Old', in *Moments of Vision*, London 1981, pp.160–80, 174

FERINO-PAGDEN 2007
Sylvia Ferino-Pagden (ed.), *Late Titian and the Sensuality of Painting*, Venice 2007, pp.146–8

FRANKLIN 1987
D. Franklin, 'Rosso, Leonardo Buonafé and the Francesca de Ripoi altar-piece', *The Burlington Magazine*, October 1987, vol.129, no.1015, pp.652–62

FRANKLIN 1994
D. Franklin, *Rosso in Italy*, New Haven 1994

GORDON 2003
D. Gordon, *The National Gallery Catalogues: Fifteenth-Century Italian Paintings*, London 2003

HACKNEY 1982
S. Hackney (ed.), *Completing the Picture: The Materials and Techniques of Twenty-six Paintings in the Tate Gallery*, London 1982, p.46

HIRST AND DUNKERTON 1994
M. Hirst and J. Dunkerton, *Making and Meaning: The Young Michelangelo*, London 1994, p.37, p.58, p.111

HOPE 2003
C. Hope, 'Titian's Life and Times', in *Titian* [National Gallery exhibition catalogue], London 2003, pp.25–8

HOUSE 1988
John House, *Monet: Nature into Art*, New Haven 1988

HUMFREY 1983
P. Humfrey, *Cima da Conegliano*, Cambridge 1983, cat.46, p.100

HUMFREY 2007
P. Humfrey, translation of Vasari's *Life of Titian*, in *Titian: the Complete Paintings*, Antwerp 2007, p.383

KÁRPÁTI AND SERES 2013
Z. Kárpáti and E. Seres, *Raphael: Drawings in Budapest*, Budapest 2013

LOUVRE 2015
Louvre, Paris online collection: 'Madame
Charles-Louis Trudaine' by Jacques Louis David:
http://www.louvre.fr/en/oeuvre-notices/
madame-charles-louis-trudaine

MCCARTHY 1997
F. McCarthy, *Stanley Spencer: An English Vision*,
New Haven 1997, pp.52–4

MCHAM 2013
S.B. McHam, *Pliny and the Artistic Culture of the
Italian Renaissance*, New Haven 2013, p.46

NATTER 2012
Tobias G. Natter, *Klimt: The Complete Paintings*,
Cologne 2012, cat.236, pp.637–8, cat.241, p.640

OBERHUBER 1999
K. Oberhuber, *Raphael: The Paintings*,
Munich 1999, cat.67, cat.250

PEDROCCO 2000
F. Pedrocco, *Titian*, New York 2000, cat.136,
p.190, cat.270, p.308

PLINY 77–79 AD
Pliny, *Natural History*, 35.143–6

SCHULZ 1975
J. Schulz, 'Michelangelo's Unfinished Works',
The Art Bulletin, September 1975, vol.57, no.3,
pp.366–73

SHEARMAN 1965
J. Shearman, *Andrea del Sarto*, Oxford 1965, vol.I,
pp.110–11, vol.II, pp.269–70 and pp. 280–2

SOHM 2007
P. Sohm, *The Artist Grows Old*,
New Haven 2007

SPEAR 1997
Richard E. Spear, *The 'Divine' Guido*,
New Haven 1997, pp.299–320

VASARI 1550
Vasari, *Life of Leonardo*

VASARI 1550
Vasari, *Life of Michelangelo*

VON ERFFA AND STALEY 1986
H. Von Erffa and A. Staley, *The Paintings of
Benjamin West*, New Haven 1986, pp.218–19

FURTHER READING

NICO VAN HOUT
The Unfinished Painting, Antwerp 2012

PHILIP SOHM
*Pittoresco: Marco Boschini, his Critics and their
Critiques of Painterly Brushwork in Seventeenth-
and Eighteenth-Century Italy*, Cambridge 1991

ACKNOWLEDGEMENTS

Sincere thanks to Richard Thomson and
John Leighton for inviting me, and for memorable
Edinburgh hospitality; to Soni as always; and
for James and Angelica for being there too.